All of the photographs and drawings featured in this coloring book are by Mary K. Hanson, a Certified California Naturalist and author of the *"Cool Stuff Along the American River"* series of species guides for everyday folks and budding naturalists available through Lulu.com. Ms. Hanson volunteered all of the hours it took to create this book.
All profits from this book go directly to Tuleyome to help fund its "Nature and You" lecture series and other programs.

Nature and You

Tuleyome's Adult Coloring Book
Compiled by Mary K. Hanson for Tuleyome

© Copyright 2017, Tuleyome. All Rights Reserved.
ISBN: 978-1-365-21367-0

Tuleyome is a 501(c)(3) nonprofit conservation organization based in Woodland, California. For more information, see our website at:
http://tuleyome.org/

Tuleyome
607 North Street, Woodland, CA 95695
Phone: 530-350-2599

Columbian Black-Tailed (Mule) Deer (*Odocoileus hemionus columbianus*). There is some controversy in the scientific community as to whether these deer are a distinct species or a subspecies of Mule Deer. Whichever they may be, these deer are the ones most widely found throughout the Berryessa Snow Mountain National Monument region. Bucks shed and regrow their antlers every year. The antlers are covered with "velvet" in the early summer, and then the velvet is shed right before the rutting season in the fall.

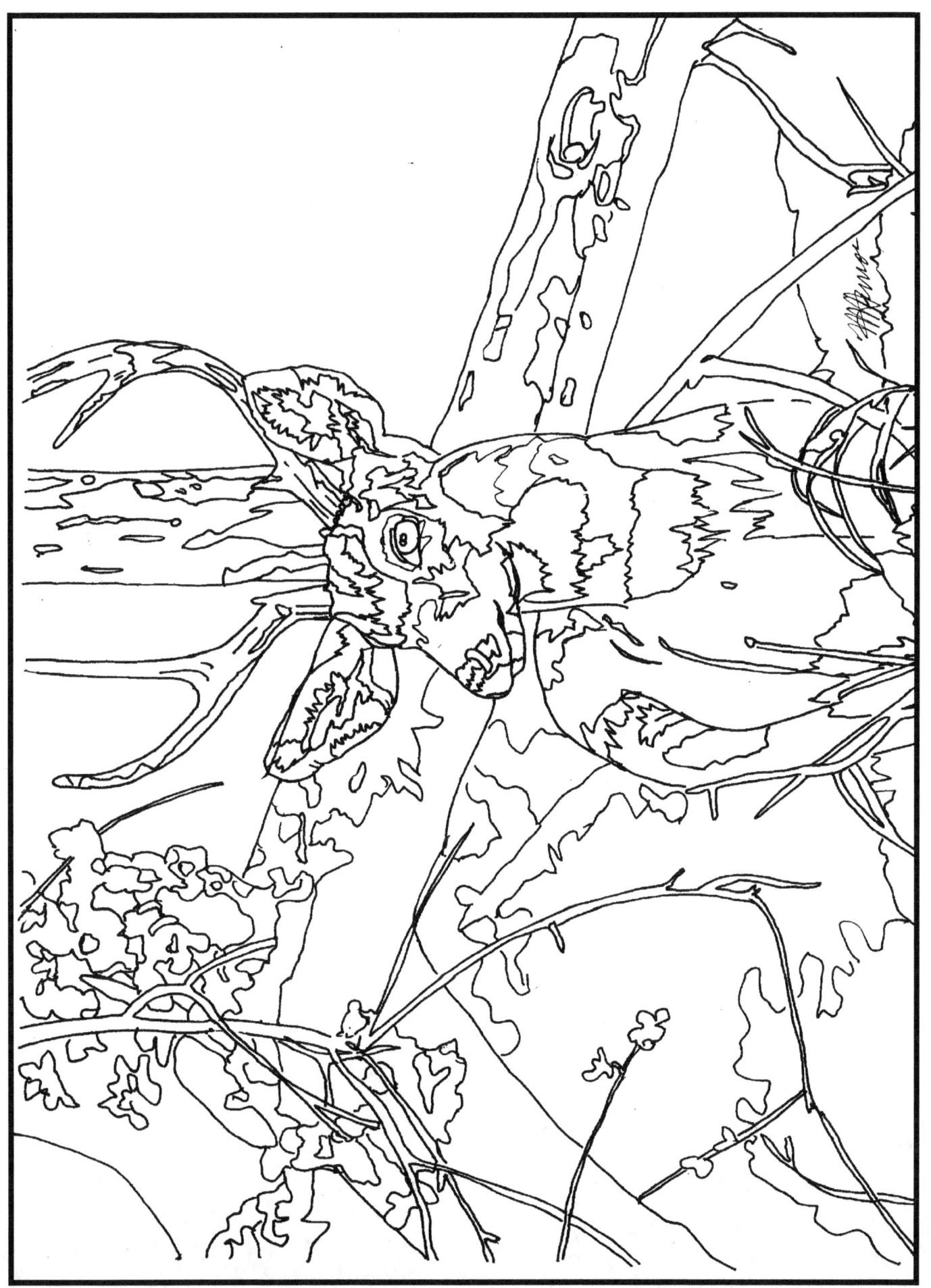

American Bullfrog (*Lithobates catesbeianus*). This very large frog with its deep throaty croak is native to the eastern states of North America, but here in California it is considered an invasive species that competes with native frogs for food and living space. Female bullfrogs can lay up to 40,000 eggs in one year. Bullfrogs, which can weigh up to a pound and ambush their prey (including worms, insects, fish and native frogs) can jump a distance up to ten times their body length.

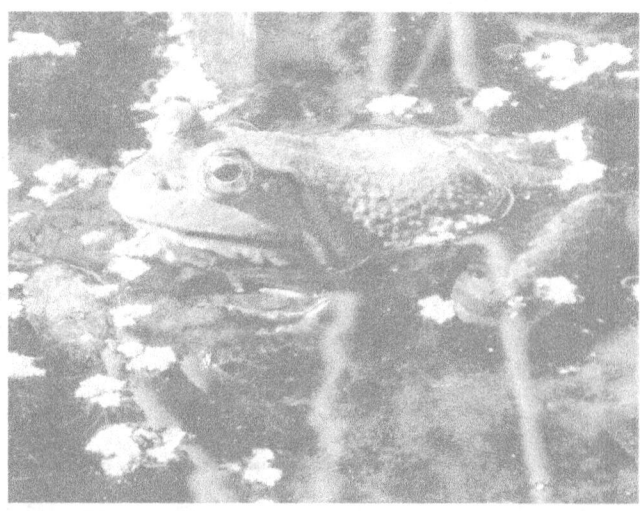

The **Variegated Meadowhawk Dragonfly** (*Sympetrum corruptum*) is a prolific native species found throughout the region. Adult males are red, and females and juveniles are golden yellow. They're easily identified by the white spots running along the sides of their abdomen. Like all dragonflies, the Variegated Meadowhawks spend the majority of their lives underwater as voracious aquatic nymphs known as *"naiads"*. When the nymphs are mature enough, they climb out of the water, shed their skin (called *"exuvia"*) and emerge as winged dragonflies. Nearly half of California's dragonfly and damselfly species live in the Berryessa Snow Mountain National Monument region.

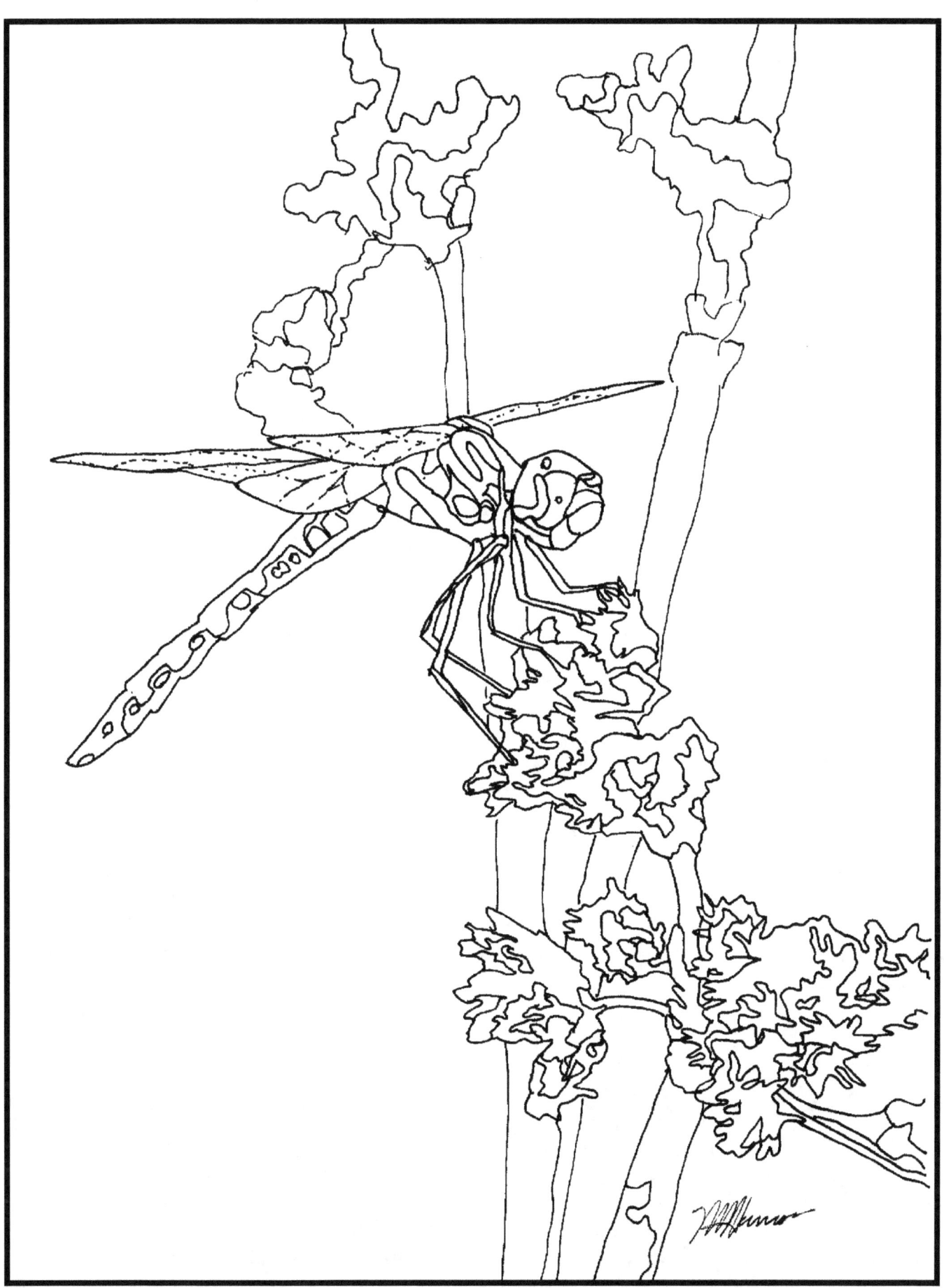

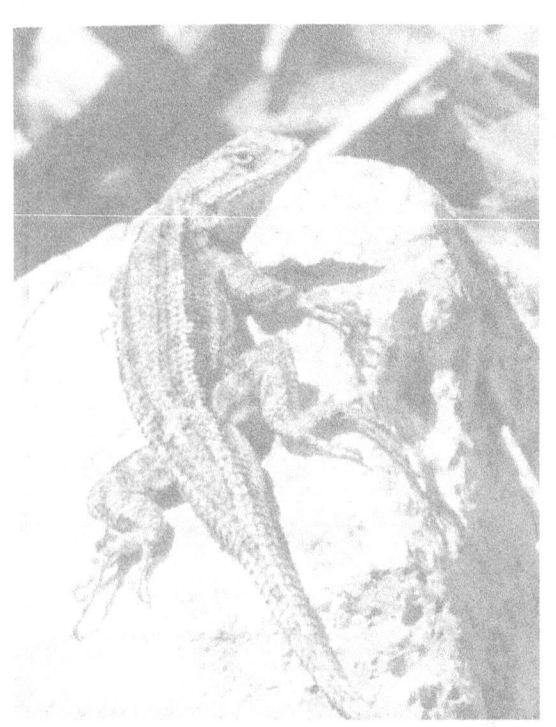

Western Fence Lizard (*Sceloporus occidentalis*). This common native species is also called the Blue-Belly Lizard for the dramatic blue splotches of color under he male's chin and on its belly. In adults, the armpits are tinted with bright yellow, and sometimes the blue coloration also appears in the scales on the lizard's back. These are the lizards you often see doing "push-ups" on rocks, logs or fence posts throughout the region. That behavior is actually part of their territorial posturing rituals. Not be confused with California Alligator Lizards (which have smooth scales) the Western Fence Lizard has rough "*keeled*" scales. Did you know that a protein in this lizard's body can actually kill the bacterium that causes Lyme Disease? It's true!

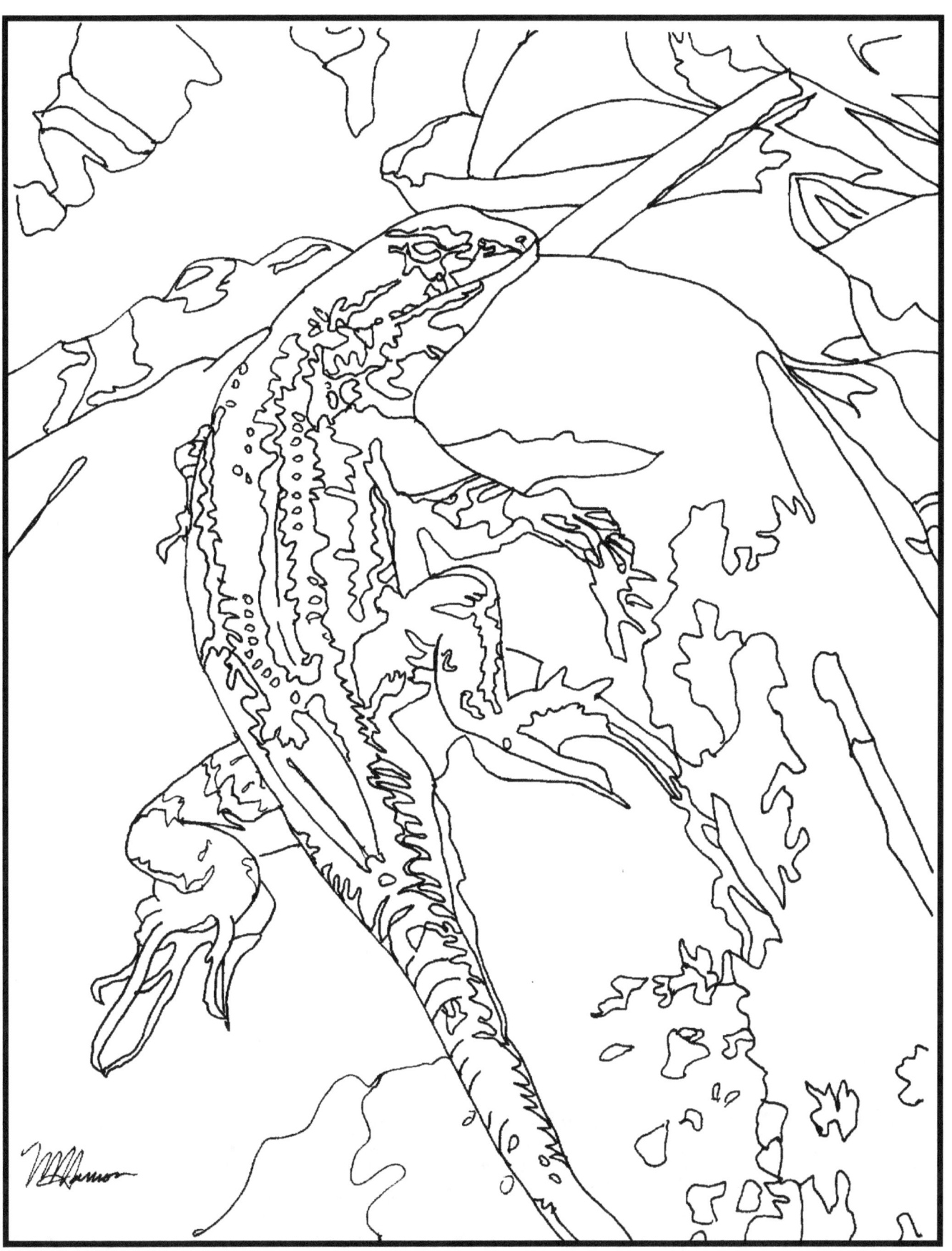

Female Wood Duck (*Aix sponsa*) and her ducklings. The males of the species are brightly colored with iridescent green, chestnut brown and white, but the females, like this one, are grey-brown with speckling on the breast and some iridescent blue feathers in their wings. Their eyes are outlined in yellow and white. Wood Ducks are actually quite small, in comparison to species like Mallards, and often nest in tree cavities left behind by woodpeckers like the Northern Flicker. They also adapt well to man-made duck boxes.

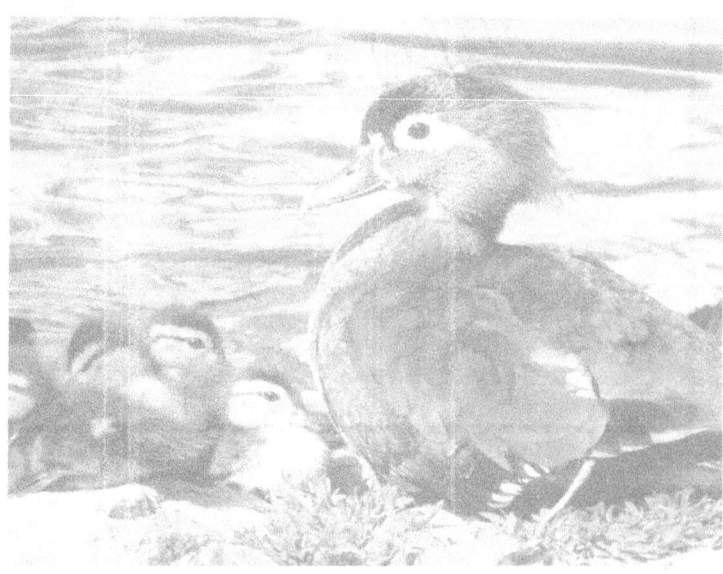

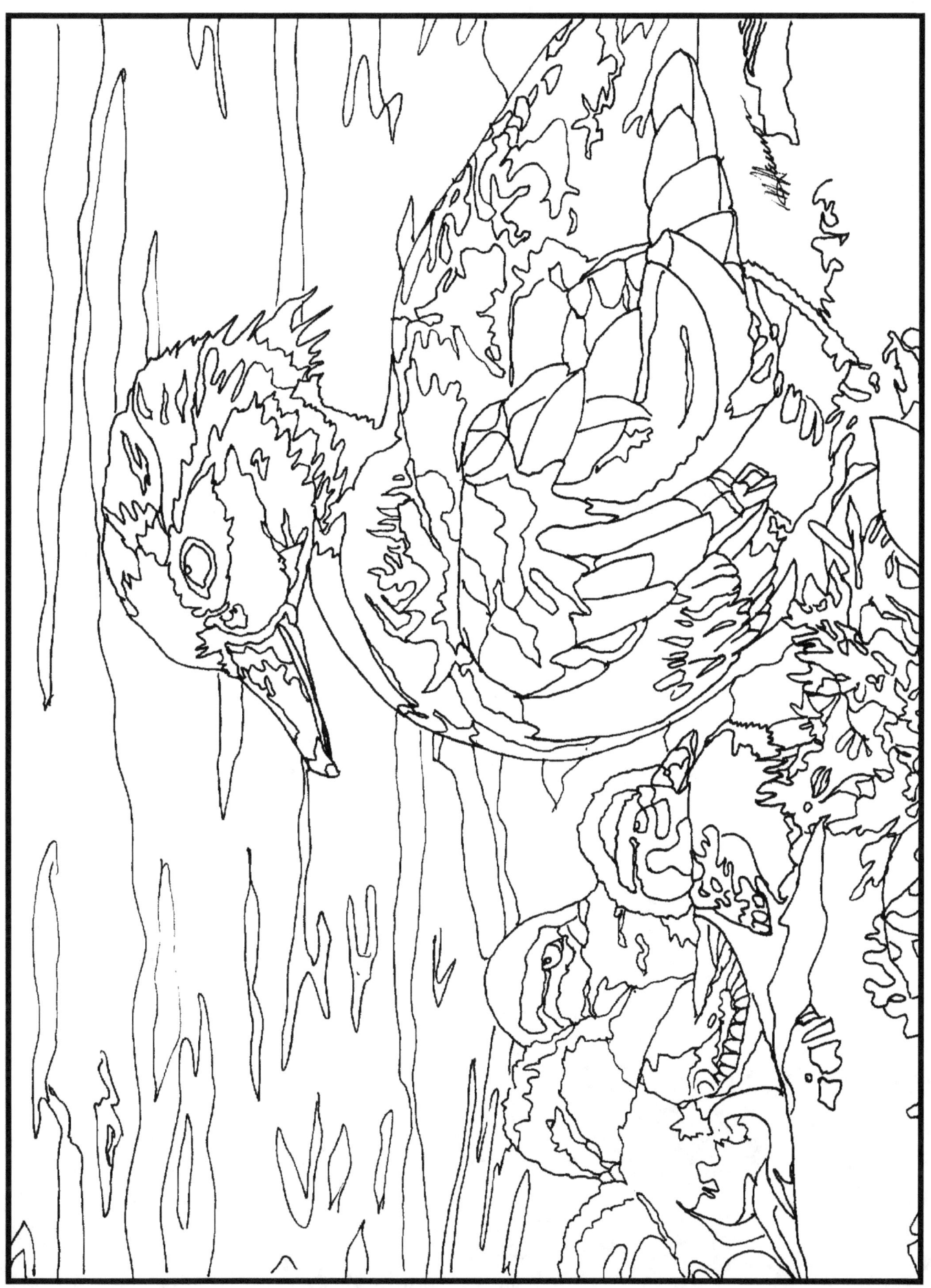

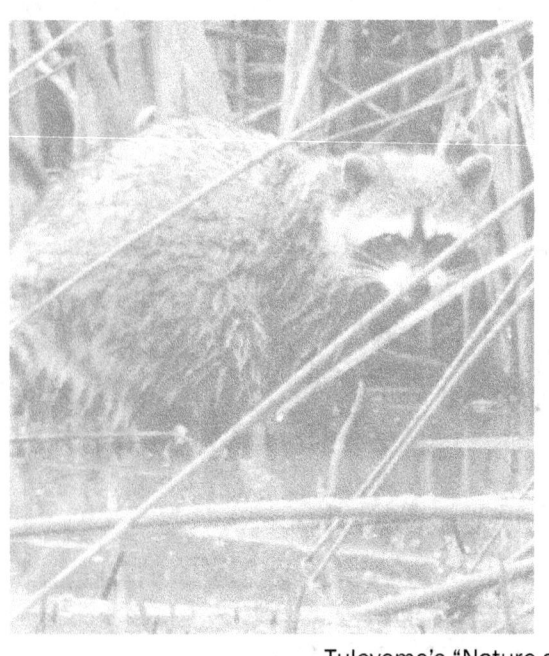

North American Raccoon (*Procyon lotor*). Raccoons have a very complex language system and use over 200 sounds to communicate with one another. Although adult raccoons are generally loners, females (called "sows") have their litters in the late spring or early summer, and during the summer months you can often find them traveling with their offspring as they look for food. Sometimes thought of as a nuisance species, raccoons actually provide a valuable service to the ecosystems they inhabit. Like small masked garbage collectors, they help to clean up and clear out plant and animal refuse, and they also control overpopulation in the animal world by eating things like rats, mice, frogs, snakes and crawfish.

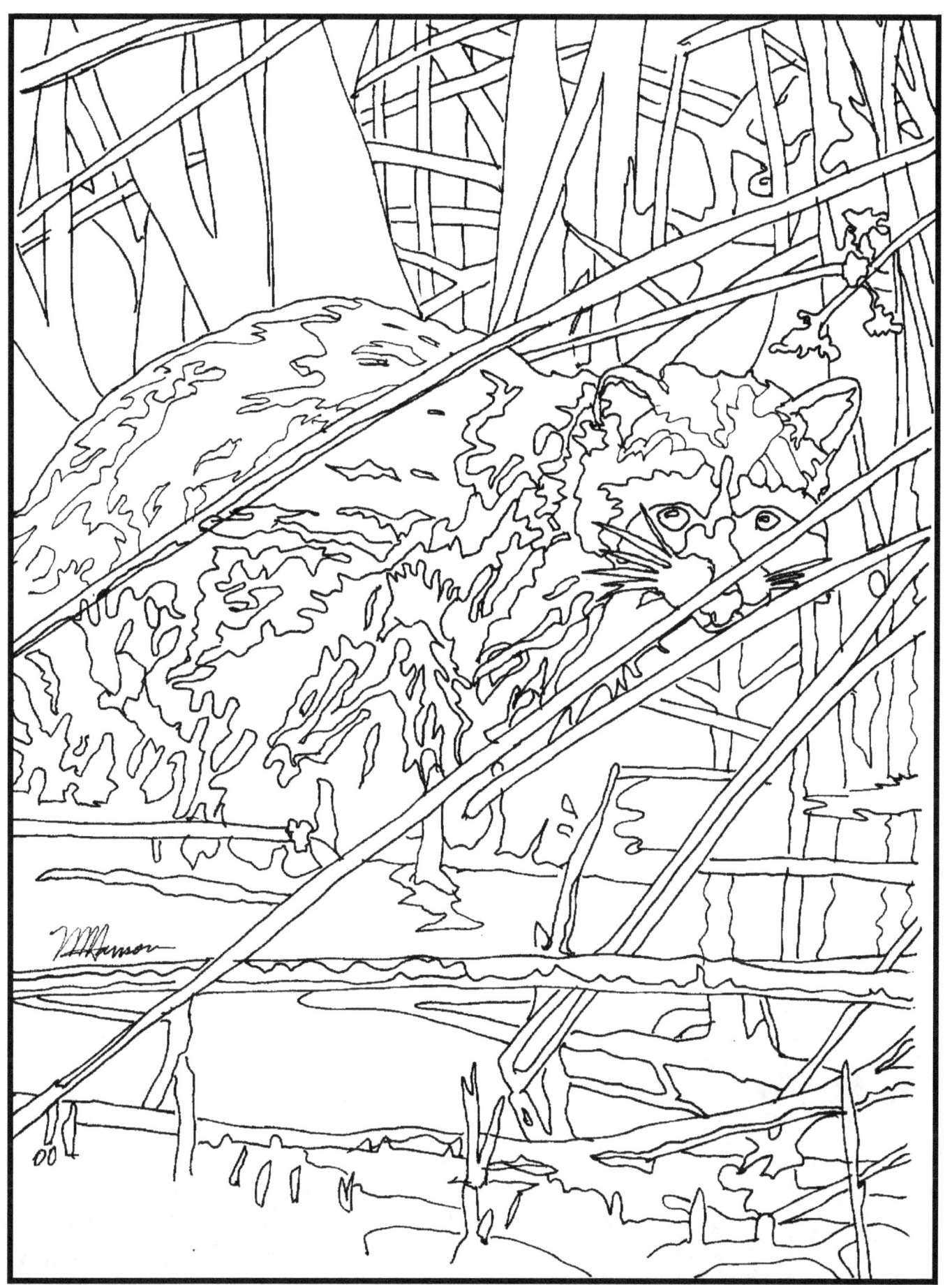

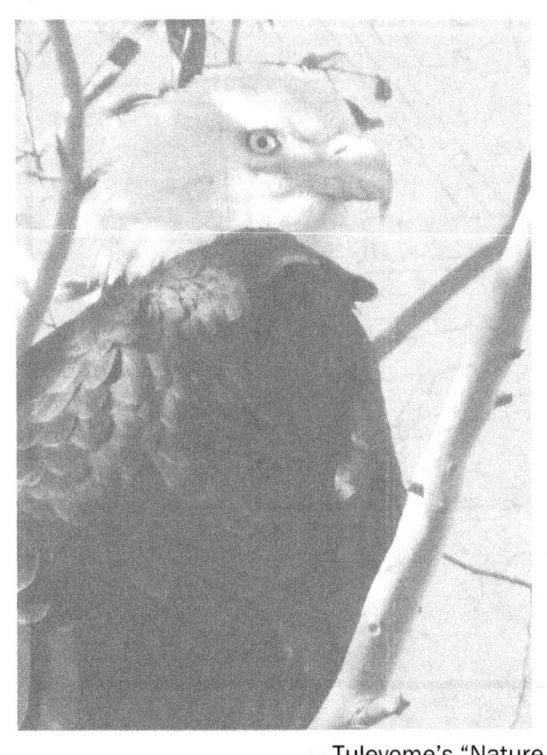

Bald Eagle (*Haliaeetus leucocephalus*). These eagles can live for up to 20 years in the wild, can dive at speeds up to 99 miles per hour, and mate for life. Females have the same coloring as the males but are about one-third larger than the males, weigh more, and have a wingspan of about 8 feet (whereas the males' wingspan is about 6 feet). The eagles don't get their distinctive white head until they're at least four years old. Darker juveniles are often mistaken for Golden Eagles, but an easy way to tell them apart is to look at the feet. If the leg feathers reach down and cover the toes, it's a Golden Eagle. If the "ankles" and feet are bare, it's a Bald Eagle. The Berryessa Snow Mountain National Monument region is home to the second largest population of wintering Bald Eagles in the state of California.

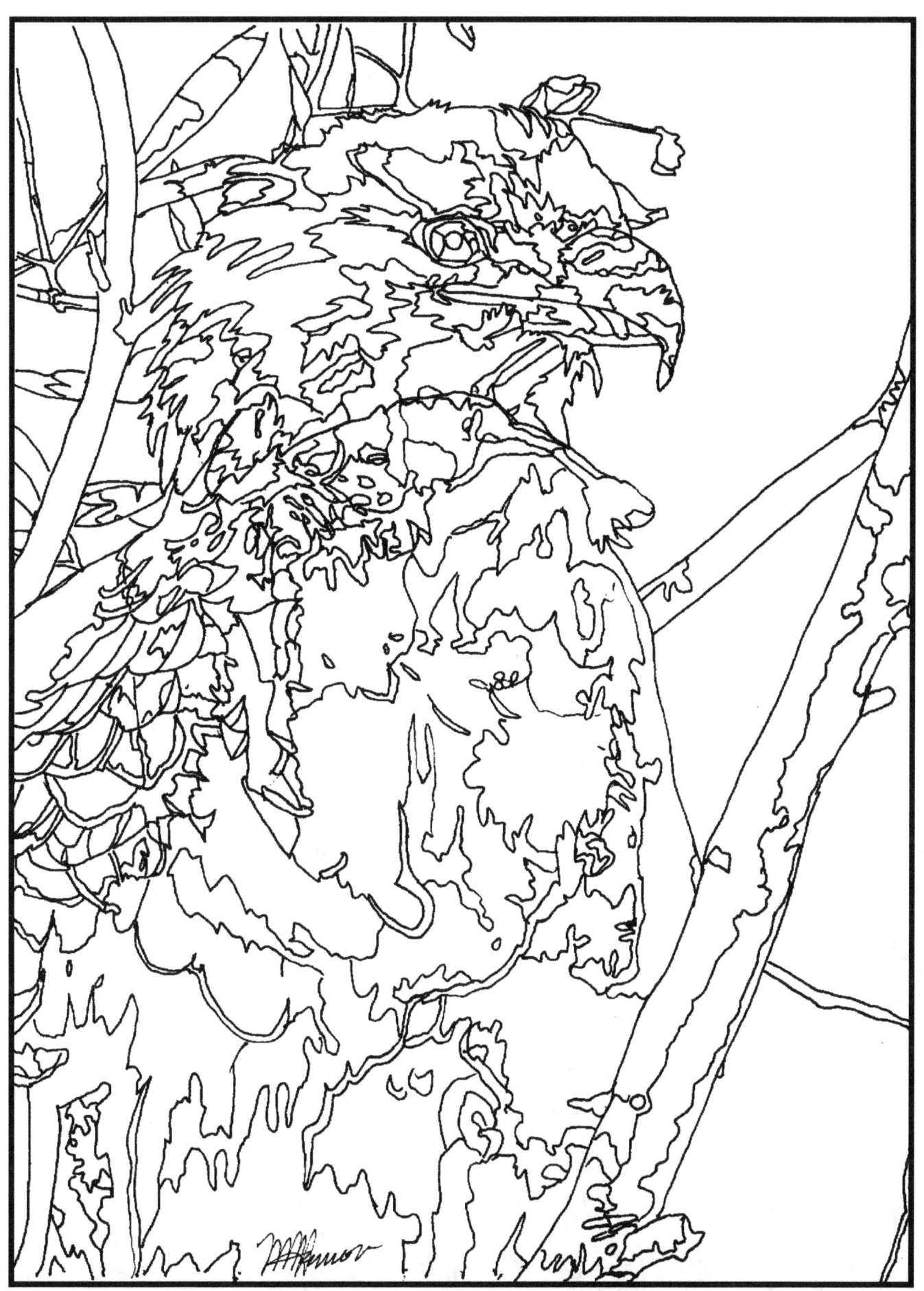

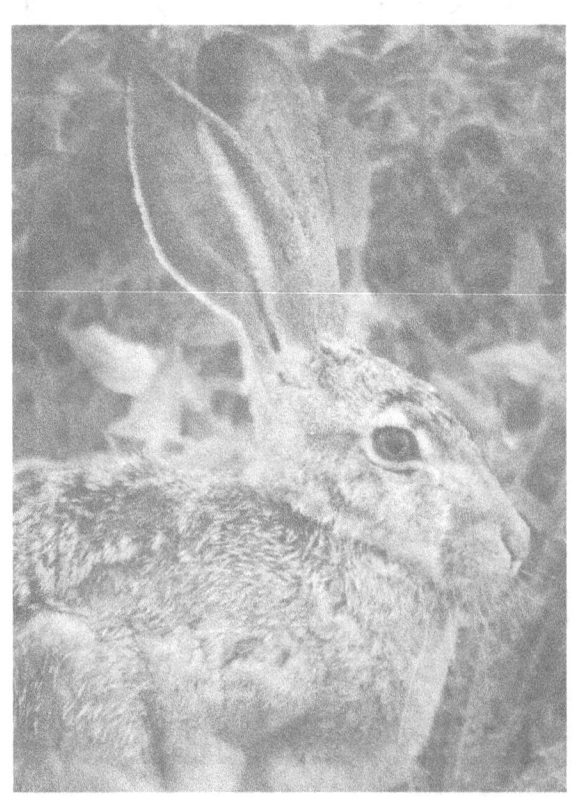

Did you know that the Black-Tailed Jackrabbit (*Lepus californicus*) isn't a rabbit at all? It's a hare! Hares are larger than rabbits and usually have longer ears. But there are other remarkable differences: Rabbits (like Cottontails) have their babies (called "bunnies" or "kits") underground in burrows called "warrens". The bunnies are born furless, blind and deaf, and stay underground with their mother until they're about 4 to 6 weeks old. Jackrabbits have their babies (called "leverets") above-ground in "forms" made of hollowed out dirt and grass. The newborn leverets are fully formed, have all of their fur and can see and hear… And they are up and running after mom within <u>hours</u> of their birth. The Jackrabbit's distinctive long ears help it to balance itself when it's running, and also act as a heating and cooling system for the jackrabbit's body.

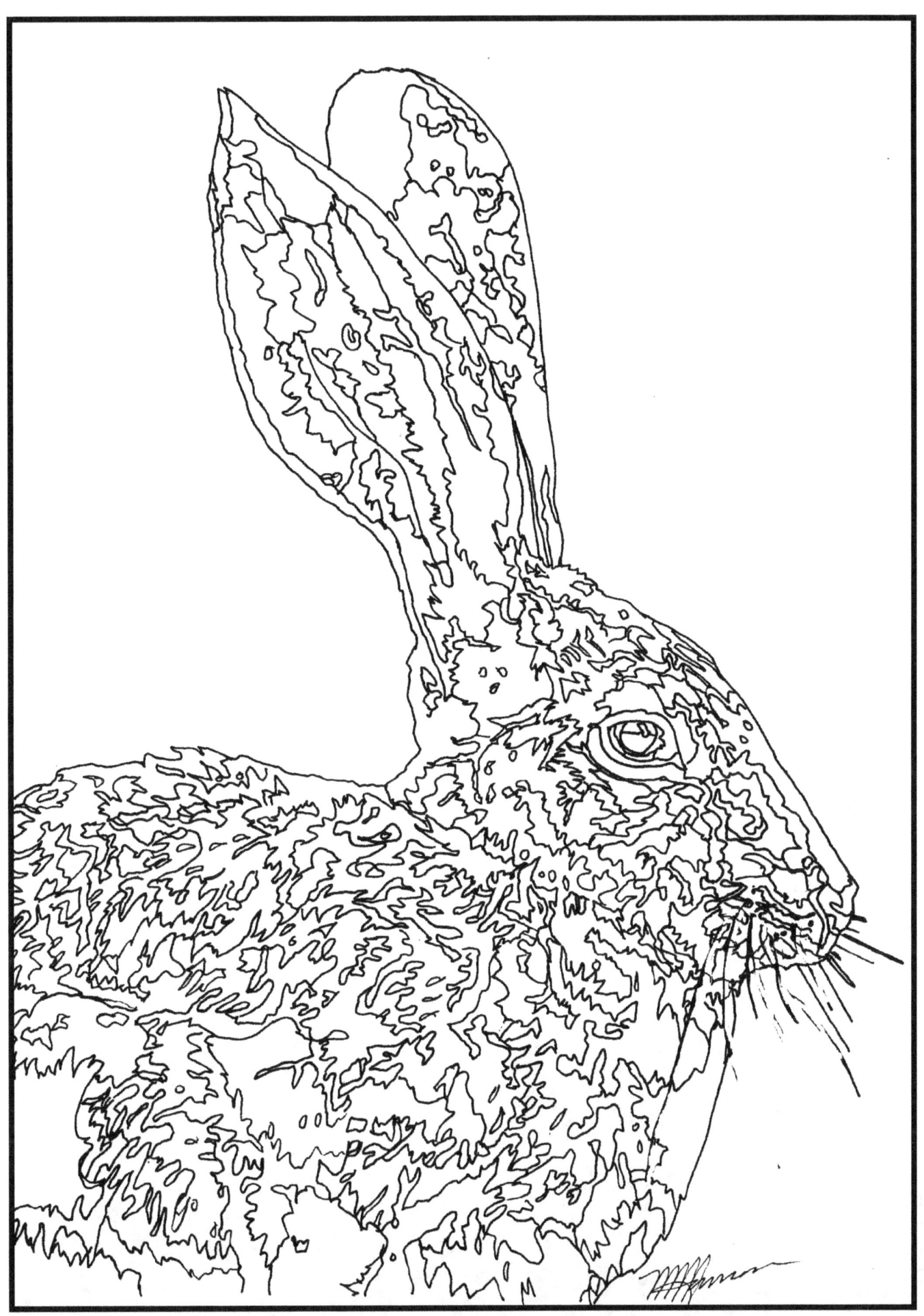

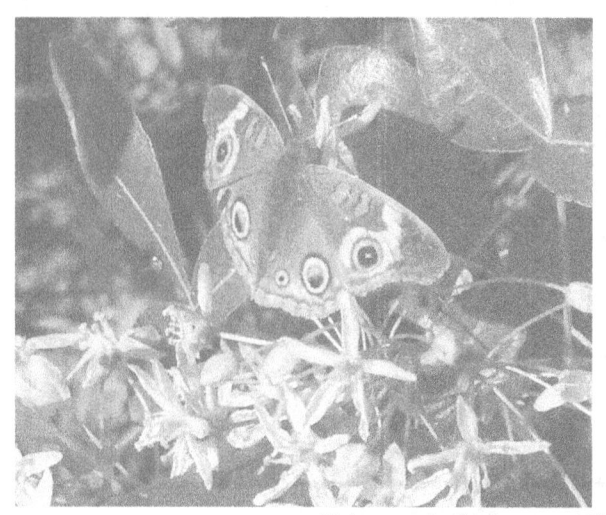

Common Buckeye Butterfly (*Junonia coenia*). This is a small butterfly usually seen in the summer months in the region, but it's active between May and October and during that period it may have up to three broods. The distinctive "eye-spots" on the wings make it easy to identify. Females lay their eggs on snapdragon and plantain plants. Their caterpillars are usually striped black, white and orange with bristly spikes protruding from the body.

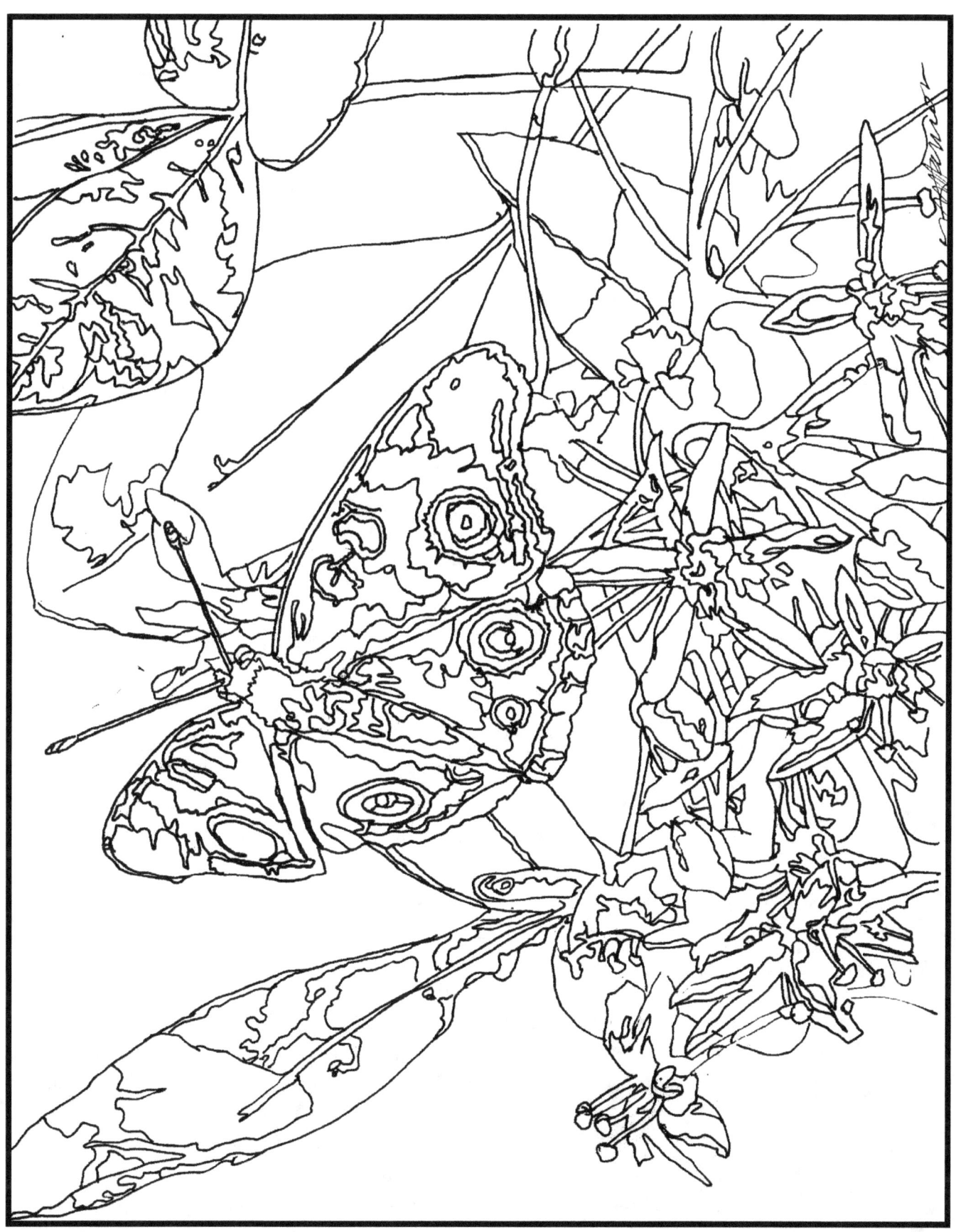

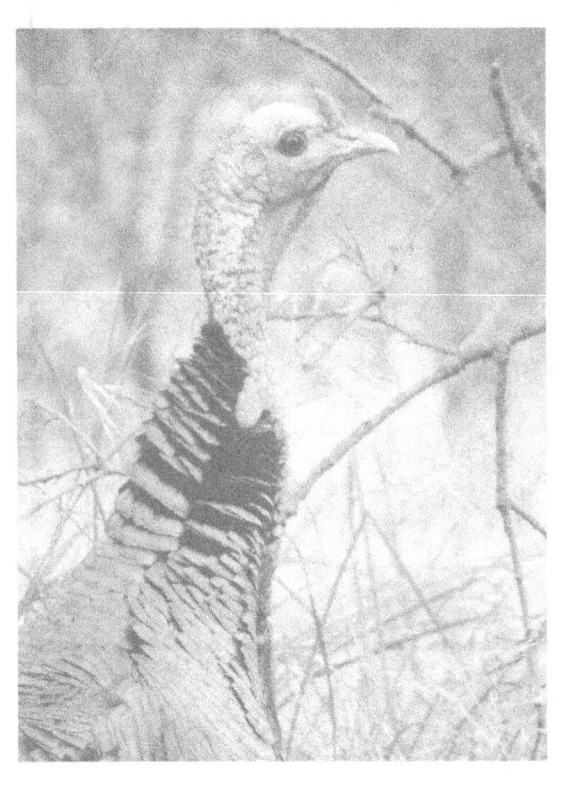

The Wild Turkey (*Meleagris gallopavo ssp.*) California's native wild turkeys were hunted to extinction by the late 1800's. To replace them, Rio Grande and Merriam's Turkeys were introduced into the state, and are now well established here. When humans then expanded their neighborhoods into the birds' wild habitat, the turkeys adjusted and learned to live in urban and suburban areas. Wild animals like turkeys can become a nuisance when humans put them where they don't belong, then feed them table scraps and other food, and provide them with places to roost. Despite their reputation for being "stupid", turkeys are actually smart and very adaptable birds. If you make yourself the source of their food and lodging, they'll take advantage of what you provide. Help keep wild turkeys wild. Don't feed, house, or try to make pets of them.

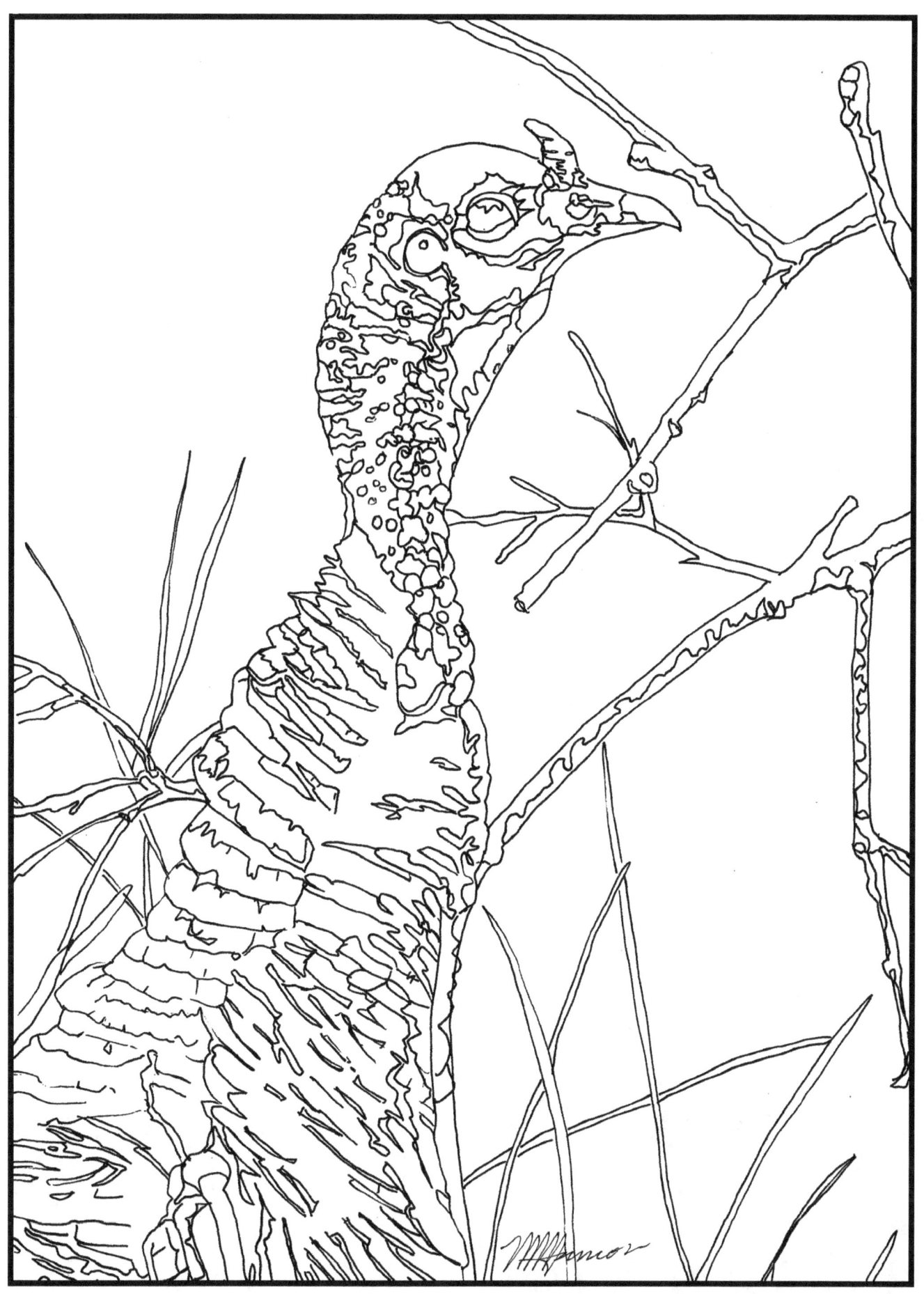

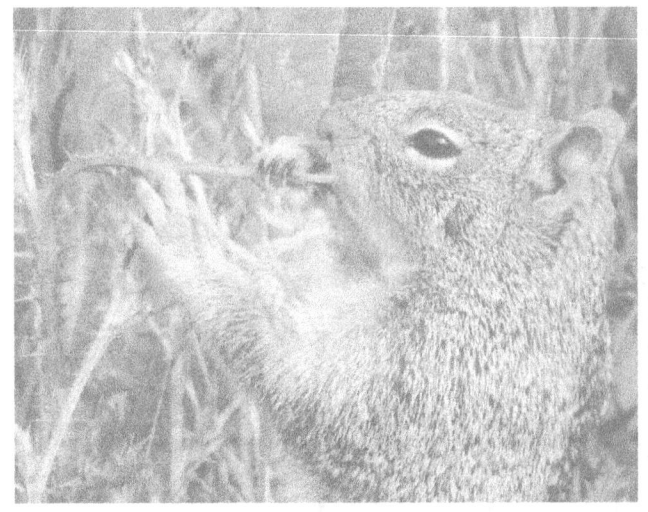

California Ground Squirrel (*Otospermophilus beecheyi*). These squirrels excavate burrows in the ground and thereby help to aerate the soil. When abandoned, the burrows are often taken over by other animals including Burrowing Owls. Adult Ground Squirrels are immune to rattlesnake venom and will often charge and kick dirt at the snakes that get too close to their youngsters. They will also chew shed rattlesnake skin into a paste and then spread it on their bodies to mask their own scent and confuse the rattlers.

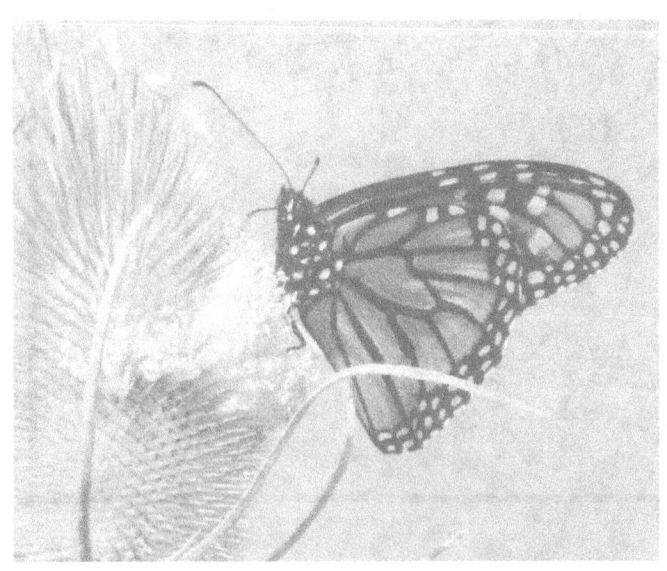

Monarch Butterfly (*Danaus plexippus*). Monarchs are seldom interfered with by predators because they are toxic. The toxicity in their bodies comes from eating their host plant - milkweed - when they're caterpillars. In fact, milkweed plants are the only plants the caterpillars will eat. These butterflies migrate up to 6000 miles round trip each year, and they only make the trip once. (Their offspring make the journey the next year.) With Monarch populations in decline, you can assist the species by planting lots of native milkweed plants in your garden.

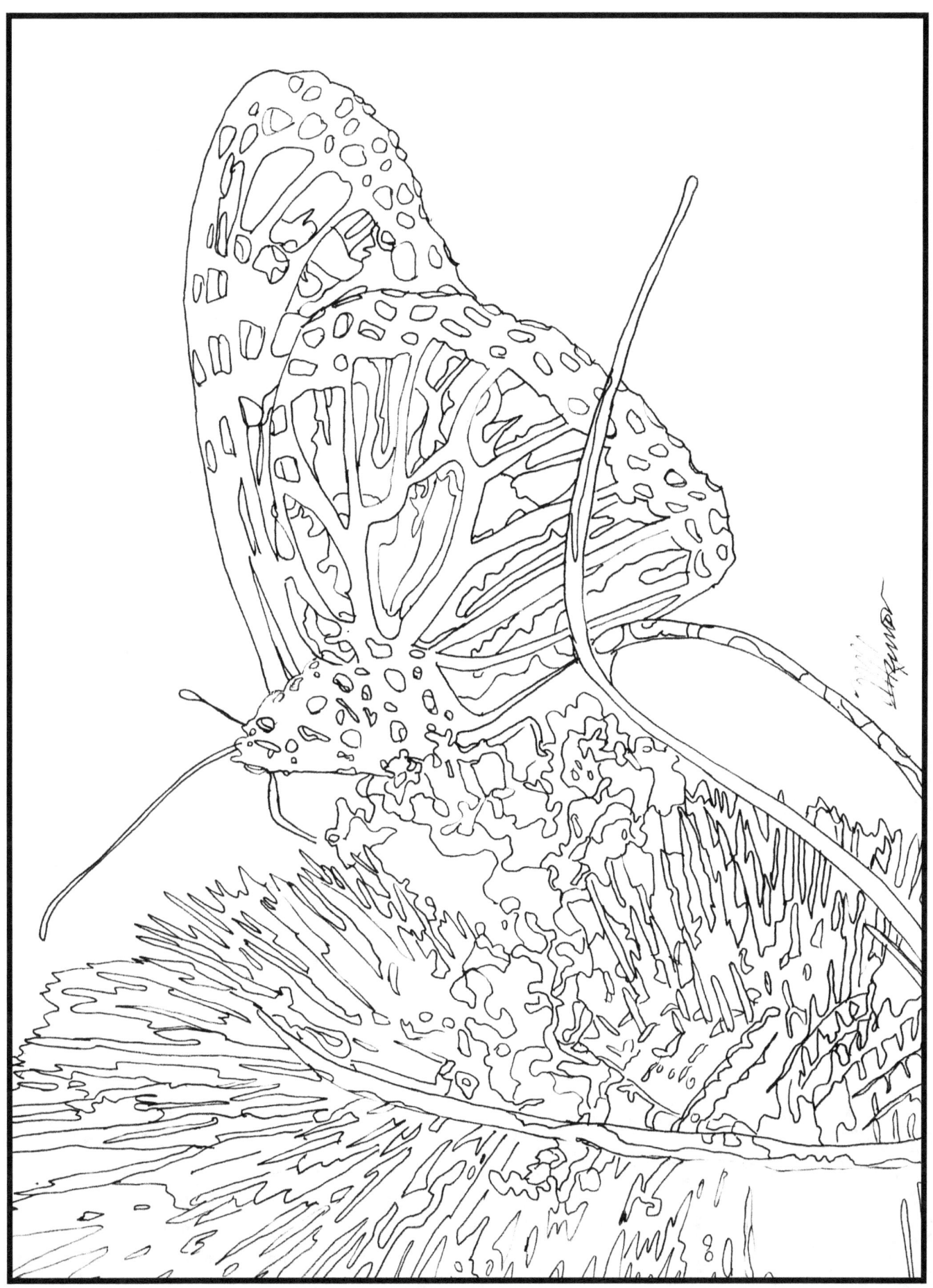

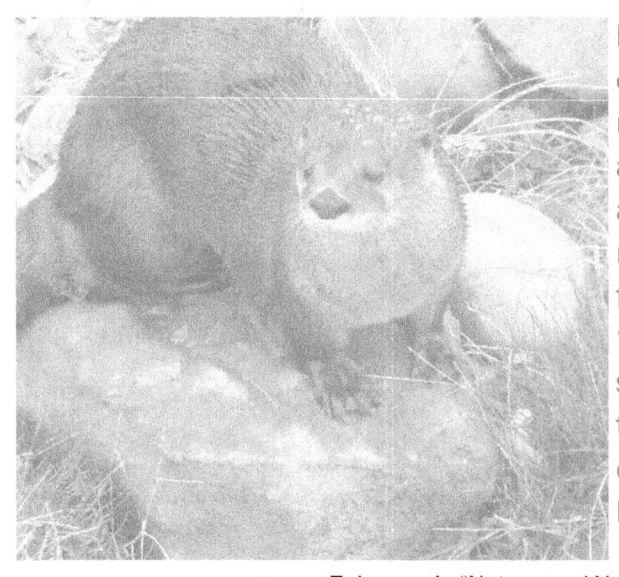
North American River Otter (*Lontra canadensis*). River otters breed between December and April, and the mama otter can have up to six pups in a litter. Pups are born fully furred, but can't see or hear until they are about a month old. Unlike European otters, female our river otters can actually delay the implantation of fertilized eggs for up to eight months, so they can "time" the birth of their pups. Those long whiskers you see on the otter's face are called "vibrissae" and help the otter to feel what's around it in murky water. The otter's feet are also highly sensitive to touch, and it has heightened senses of smell and hearing.

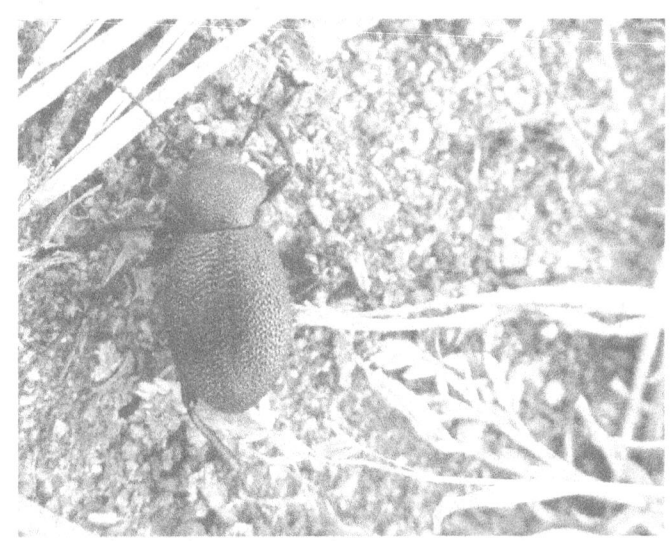

Giant Darkling Beetle (*Eleodes scabrosa*). There are more than 20,000 species of darkling beetles. They're from the insect Family *Tenebrionidae* which roughly translates as "the dwellers in dark places". This is what a mealworm looks like when it grows up. Darklings take their place in the environment as cleaner-uppers eating decaying plant materials, other dead insects and fungi. This particular beetle is also known as a "stink beetle" because when cornered or attacked it will raise its hind end and skunk its attacker.

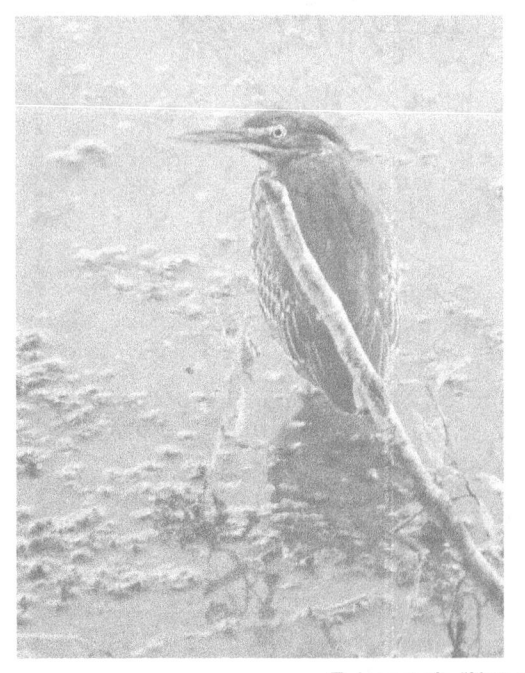

Green Heron (*Butorides virescens*). The smallest heron in California, the Green Heron sometimes doesn't look very green from a distance; more brown and dark gray. But when the sunlight hits it, its true rich browns and deep iridescent green colors show off. The green coloring turns darker and sharper as the bird ages. Although they usually lay flat, the crown feathers on the heron's head rise up (something like those of a cockatoo) when it's agitated. This is one of the few species of bird that has learned to use tools and passes its knowledge onto its offspring. Green Herons will often select dead insects, feathers, or leaves and then place them on the top of the water to attract fish. When the fish come up to investigate the lure, the heron grabs and eats them.

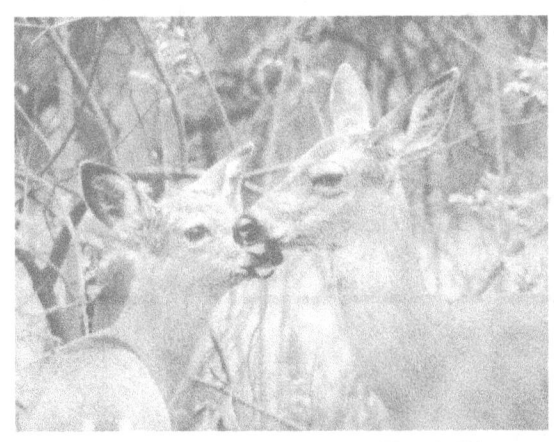

Columbian Black-Tailed (Mule) Deer (*Odocoileus hemionus columbianus*). Females give birth to fawns between May and June in our region, and usually have twins (although single births and triplets sometimes occur). The fawns have no scent during the first 7 to 10 days. This allows the mother to leave them safely unguarded while she searches for food. If you find a fawn alone, do not try to "rescue" it. Its mother is most likely nearby and will return for it.

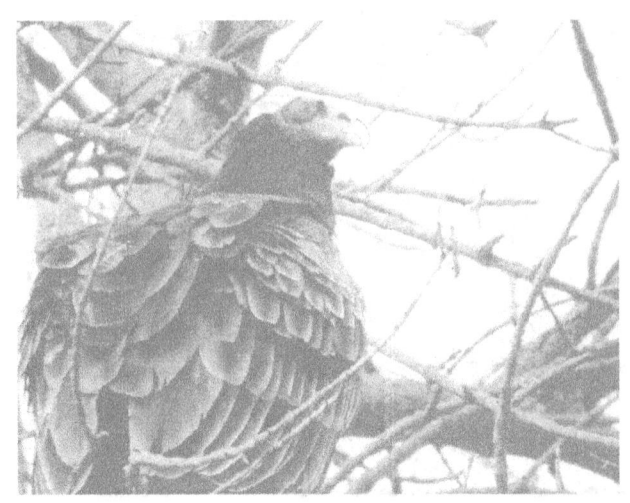

Turkey Vulture (*Cathartes aura*). Although they're grouped in with other raptors like hawks and owls, Turkey Vultures aren't really equipped to capture live prey. They are carrion-eaters who hunt by smell, not by sight. They are so skillful with their beaks that they can remove the scent-gland from a dead skunk without getting "bombed", and their immune systems are so greatly developed that they can eat carcasses -- including those affected by anthrax, botulism or cholera -- without getting sick.

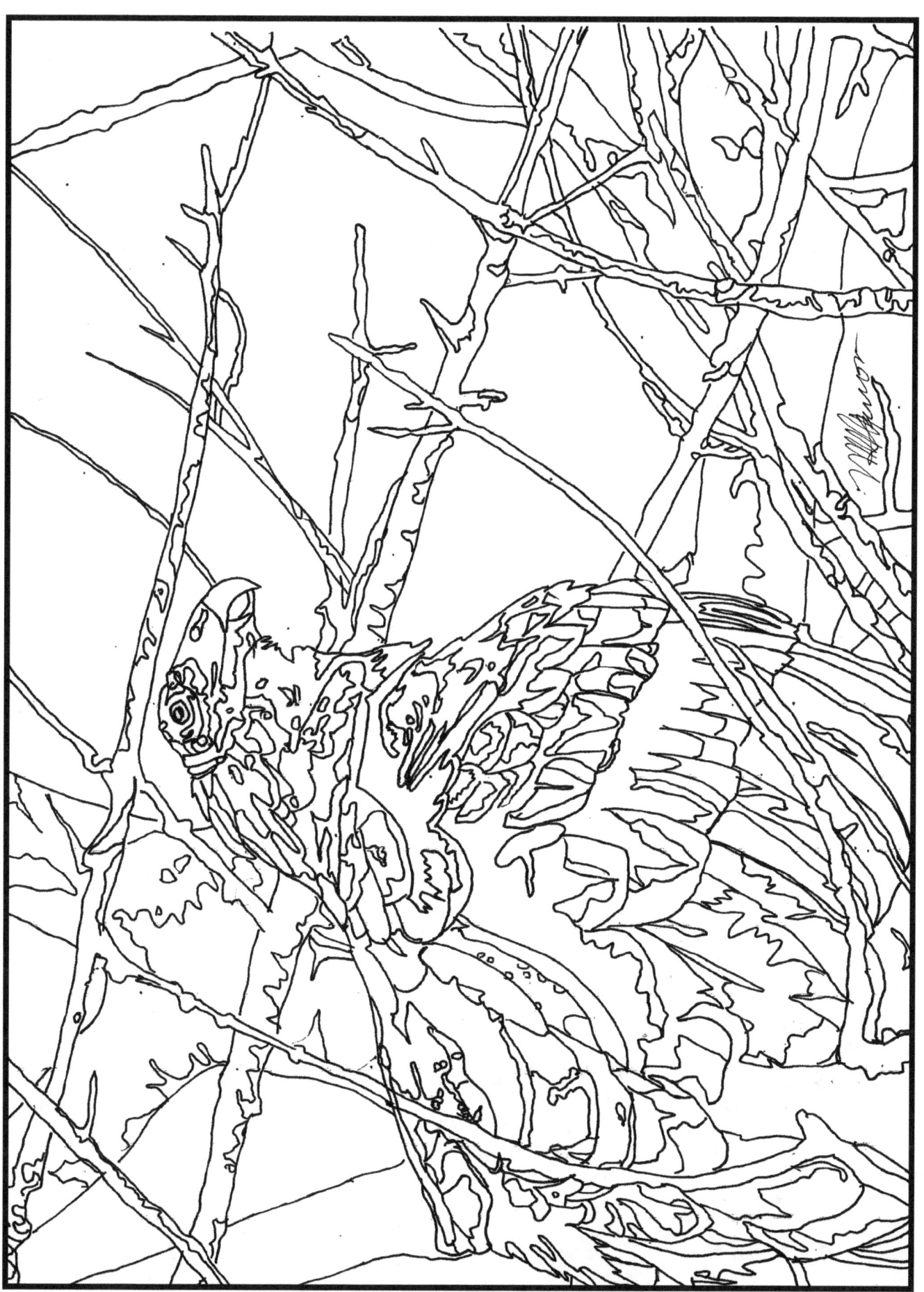

These are the caterpillars of the California Pipevine Swallowtail butterfly (*Battus philenor hirsuta*), a native and endemic species in California whose life depends on pipevine plants. Female Pipevine Swallowtail butterflies will only lay their eggs on pipevine plants; and their caterpillars will eat nothing but pipevine. The host plant supplies the caterpillars and butterflies with a substance called *aristolochic acid* which makes them toxic to predators. The adult butterflies are black with blue hindwings.

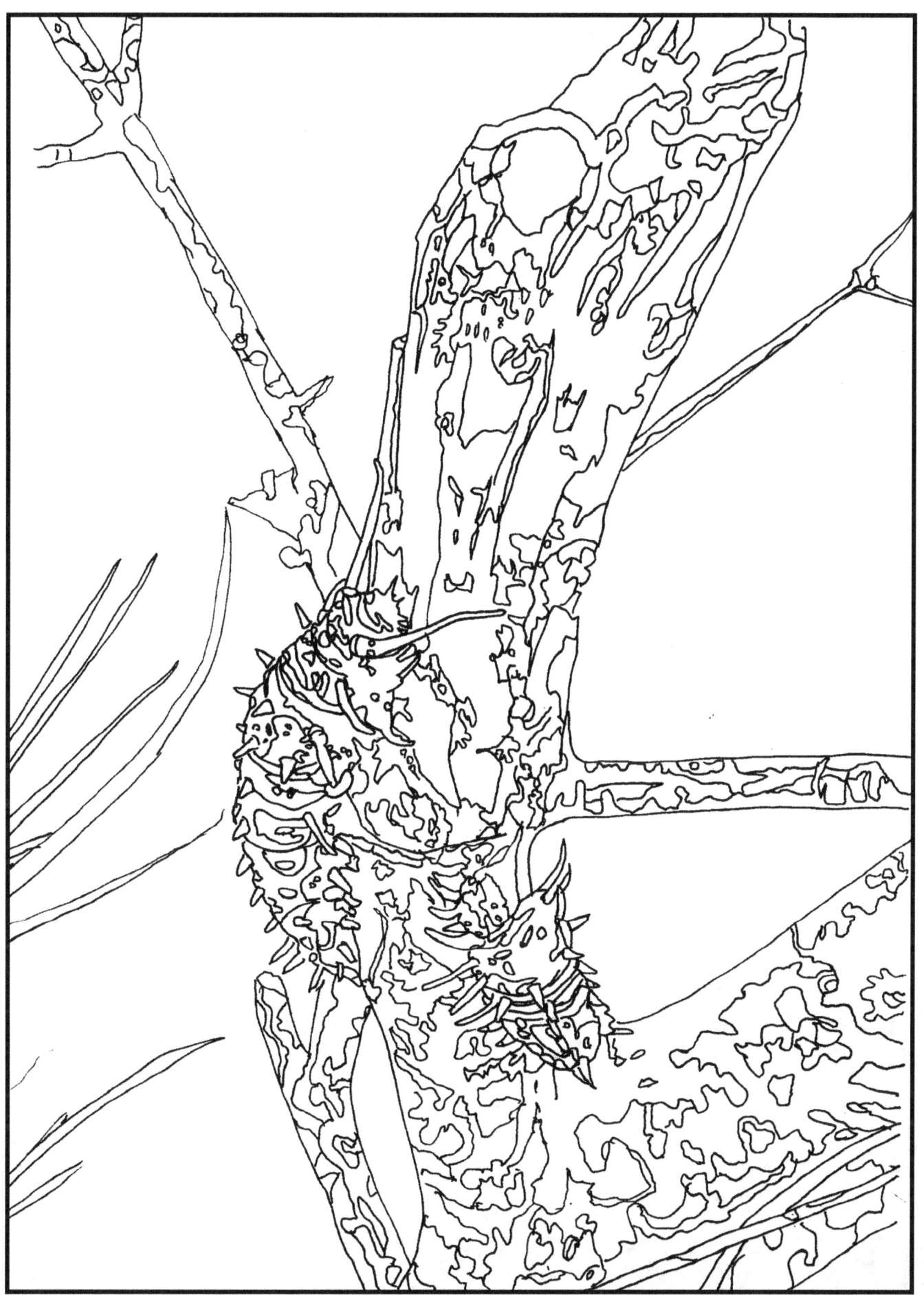

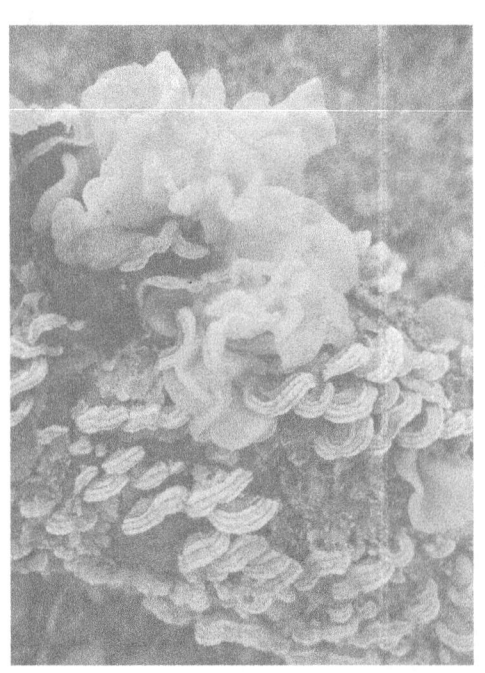

Witch's Butter (*Tremella mesenterica*) is a yellow-orange jelly fungus that's found throughout the Berryessa Snow Mountain region after soaking rains. Like all jelly fungi, this one is about 60% water. When it's hydrated it feels slippery and rubbery to the touch. When dry, it feels like parchment or tissue paper. There are also other species of black, white, brown, and translucent jelly fungi. This particular jelly is a parasite and its favorite food is Turkey Tail fungus (the fungus you see in this photo made up of colored concentric rings). Turkey Tail is a kind of polypore fungus, often confused with False Turkey Tail which is a bracket fungus. To tell them apart look at the back of the "tail". If the backside is white and porous it's Turkey Tail. If the backside is brown, shiny and smooth, it's False Turkey Tail.

Tuleyome
607 North Street
Woodland, CA 95695
Email: info@tuleyome.org
Phone: 530-350-2599
Web: http://tuleyome.org/

Tuleyome is a 501(c)(3) nonprofit conservation organization based in Woodland, California. The word "Tuleyome" (pronounced too-lee-OME-ee) is a Lake Miwok Indian word that means "deep home place". And that term "deep home place" exemplifies our deep connection to the environment, our communities, and our regional public lands.

VOLUNTEER: Volunteers are the heart of Tuleyome, without you we would not be able to get so much great work done. Consider signing up as a volunteer today! We need hike leaders and sweeps, folks to work on our restoration projects, folks to help us with tabling events, and folks willing to do low-impact things like photography, scrapbooking and clerical work. You can also donate your time as a guest lecturer or volunteer your business space for our meetings and fundraising events. Have other ideas for volunteering? Give us a call!

DONATE: Anyone can be a philanthropist. When you donate $35, $50, $100 or more to Tuleyome you not only support our mission and programs, you also establish yourself as a friend to the environment and a contributor to your community.

BERRYESSA SNOW MOUNTAIN NATIONAL MONUMENT: We spearheaded this campaign and Berryessa Snow Mountain region is now a National Monument thanks to you and your hard work! Find out what is going on within the monument and with the Resource Management Plan on our website.

HOME PLACE ADVENTURES: At Tuleyome, we believe that everyone deserves access to the outdoors. Our nationally award-winning program, Home Place Adventures, encourages people of all ages to become more connected to and involved with the natural world that surrounds us.

TULEYOME YOUTH BOOT BANK: The Tuleyome Boot Bank is a youth hiking boot lending program that provides high quality hiking boots to local youth at no cost for the duration of their physical growth. The Boot Bank, operated out of an antique milk truck by Davis Boy Scout Troop 111, will appear at scheduled community locations.

INNER COAST RANGE CONSERVANCY PROGRAM: Tuleyome is spearheading the establishment of the Inner Coast Range Conservancy. The northern inner Coast Range region is largely under-served among similar programs in California and merits a Conservancy program as a matter of fairness and equity, and the Inner Coast Range Conservancy will bring additional funding and capability for implementing locally valued programs to the region.

BERRYESSA SNOW MOUNTAIN TRAILS INITIATIVE: Comprised of a wide variety of

stakeholders from within the Berryessa Snow Mountain region the Berryessa Snow Mountain Region Trails Initiative's goal is to enhance public access to the Berryessa Snow Mountain region through a well-designed, constructed and ecologically sensitive regional trails system, and a sustainable maintenance program.

MERCURY MINE REMEDIATION PROGRAM: From the 1850's into the 1970's mercury ore was mined in the upper Cache Creek and Putah Creek watersheds. Mercury mined in this region was used throughout much of the Sierra Nevada in the gold mining process. (Mercury amalgamates small particles of gold. Heating later separates the gold from the mercury.) Tuleyome is implementing a $2.4 million dollar grant by the California Department of Fish and Wildlife's Ecosystem Restoration Program (ERP) to address drainage waters from the Corona and Twin Peaks Mines in northwest Napa County.

TULEYOME LAND AND CONSERVATION STEWARDSHIP PROGRAM: The mission of the Tuleyome Land Conservation and Stewardship Program (TLCSP) is to permanently protect ecological, recreational, and strategically important lands that reflect our goals and policies, and help to protect the wild heritage of the region.

CONSERVATION PLANNING AND POLICY: Tuleyome's conservation programs incorporate both practical and policy-based engagement with decision-making processes. Examples of conservation issues that we address include: the effects of regionally significant proposed actions, development of region-wide approaches for fuels and fire management, habitat requirements for late-seral wildlife species, and the incorporation of climate change resiliency in land management.

Become a friend of Tuleyome and become a part of something much larger than yourself.
https://donatenow.networkforgood.org/tuleyome

How You Can Participate in Our Ongoing Citizen Science Project

Scientists can't always get out into the field as much as the average citizen, and so they count on citizens to help collect scientific data for them on the plants, animals and insects in any given region. You can assist the scientific community by taking photographs of the species you encounter as you hike along the trails in the region and loading them up to our Species Identification Project on **iNaturalist.org**. go to **https://www.inaturalist.org/**, look for **Projects** and search for **"Tuleyome"**. You can then load your photos up on the website itself, or load them up through the iNaturalist app on your cellphone. The app is free, and participation in the data collection is free.

If you don't know the common name of the species you've photographed, try to describe it in the "what did you see" section; something like, *"blue tulip-like flower with hairy petals"*, and experts on the iNaturalist site will find a proper identification for you.

www.ingramcontent.com/pod-product-compliance
Lightning Source LLC
Chambersburg PA
CBHW081146170526
45158CB00009BA/2711